Did I Tell You Thank You?

Copyright © 2016 Jessica Larson.

All rights reserved. No part of this book may be used or reproduced by any means, graphic, electronic, or mechanical, including photocopying, recording, taping or by any information storage retrieval system without the written permission of the author except in the case of brief quotations embodied in critical articles and reviews.

LifeRich Publishing is a registered trademark of The Reader's Digest Association, Inc.

LifeRich Publishing books may be ordered through booksellers or by contacting:

LifeRich Publishing
1663 Liberty Drive
Bloomington, IN 47403
www.liferichpublishing.com
1 (888) 238-8637

Because of the dynamic nature of the Internet, any web addresses or links contained in this book may have changed since publication and may no longer be valid. The views expressed in this work are solely those of the author and do not necessarily reflect the views of the publisher, and the publisher hereby disclaims any responsibility for them.

Any people depicted in stock imagery provided by Thinkstock are models, and such images are being used for illustrative purposes only.
Certain stock imagery © Thinkstock.

ISBN: 978-1-4897-0664-5 (sc)
ISBN: 978-1-4897-0663-8 (e)

Print information available on the last page.

LifeRich Publishing rev. date: 4/19/2016

Did I Tell You Thank You?

Jessica Larson

As I have grown up, I have come to realize that I have not told you all that I have needed to say. I haven't told you thank you enough for all that you have taught.

We get wrapped up in the moment, caught up in issues that don't matter, and encased in an idea surrounded by whom we need to be for society's acceptance.

You have taught me the only acceptance I need is my own.

So I am here to Thank You

Home is wherever family is

Did I tell you thank you for teaching me the importance of family?

That a house is more than walls and beams, but it is supported from the unconditional love from family, friendship, and joy.

Did I tell you thank you for teaching me to love endlessly?

To cherish every moment, every second
To be with people you love, but with people who love you
To love deep within your heart
And to not take people for granted

Love with all your heart

Did I tell you thank you for teaching me to bold?

Because no one can be a better me, than myself

 to not be afraid of the unknown, but to walk confidently into each new journey.

to try new things that are outrageous and to never regret it

to live life without boundaries

And to let my seed blossom into something beautiful

TAKE RISKS.
IF YOU WIN, YOU WILL
BE HAPPY.
IF YOU LOSE, YOU WILL
BE WISE.

Did I tell you thank you for teaching me to speak?

to voice my opinion with clarity and good judgment

to speak up for others when they are voiceless

to not hold back my feelings and emotions

and to improve upon not only myself, but the world

Did I tell you thank you for teaching me the possibilities are endless?

for teaching me that there are no limits, and to set my expectations and priorities higher than the sky

That my destination is a journey of ongoing travels and endless achievements

REACH FOR THE SKY.

Did I tell you thank you for teaching me that giving up is NOT an option?

that in order to achieve greatness, I need to push myself to reach my goals
and to expect nothing less than the best

that anything I set my mind to I can achieve

to keep pushing forward, even when it is an uphill battle.

KEEP MOVING FORWARD.

Everything is better when giving, than receiving.

Did I tell you thank you for teaching me to serve others?

To not only assist in others in a small way, but to impact them greatly

That there is satisfaction and joy in being apart of something larger than yourself.

Did I tell you thank you for making me feel loved, and giving me a home?

for telling me that I am beautiful even when my reflection seems broken

for telling me things will get better with time

for telling me I can do it, even when I feel like giving up

for telling me I can be anything I dream to be

So Loved

Did I tell you thank you along the way, for all the things you have done for me?

Because of you, I have learned the importance of family, love, life, patience, and happiness.

And for that, I am humbly grateful.

Love,